THE
MICE BEFORE CHRISTMAS
COLORING BOOK

PICTURES BY WENDY EDELSON
STORY BY ANNE L. WATSON

A SKYHOOK COLORING STORYBOOK

What is a "coloring storybook"? It's a coloring book, a storybook, and more! You can color just the pages you want, and enjoy it like any fine coloring book. Or finish them all and create a wonderful storybook, a keepsake all your own, or one to lovingly share with children and grandchildren. Imagine their excitement—and yours too!—when you read to them from a book you helped illustrate yourself! It's a gift your loved ones can treasure forever, a true family heirloom.

This coloring storybook from Skyhook Press reveals what *else* happened on that famous "night before Christmas."

Please note: This "grayscale coloring book" has pictures already shaded in gray, calling for a different kind of coloring. But that doesn't make it harder—in fact, it makes it easier to get stunning results! For tips, search online for "grayscale coloring."

Why Choose This Coloring Storybook?

• Adapted from a children's picture book, with a story in lively verse by noted children's author Anne L. Watson, and 40 highly detailed illustrations by award-winning children's illustrator Wendy Edelson.

• For stunning results, pictures are all in grayscale, but grayscale with a difference! Much of the gray has been removed to reduce the risk of muddiness and allow more natural flesh tones, while deepest blacks have been preserved to provide full contrast.

• Printed on thicker, high-quality paper for better coloring, reduced bleed-through, and long life.

• Blank lines right on the half-title page for colorist's signature and date.

• Bonus picture page at the end for tests, experiments, or practice.

• Thumbnails of original color illustrations on the back cover to serve as suggestions, examples, and inspiration.

• Available in both paperback and hardcover. Choose between economy and ultimate durability—or practice on the paperback before tackling the hardcover!

• Pages may be freely copied for personal use. Practice on as many copies as you like before coloring in the book!

• Colored pages may be freely shared. Show off your work, give as gifts, or even sell as pieces of original art.

THE MICE
BEFORE
CHRISTMAS

Coloring by

NAME

DATE

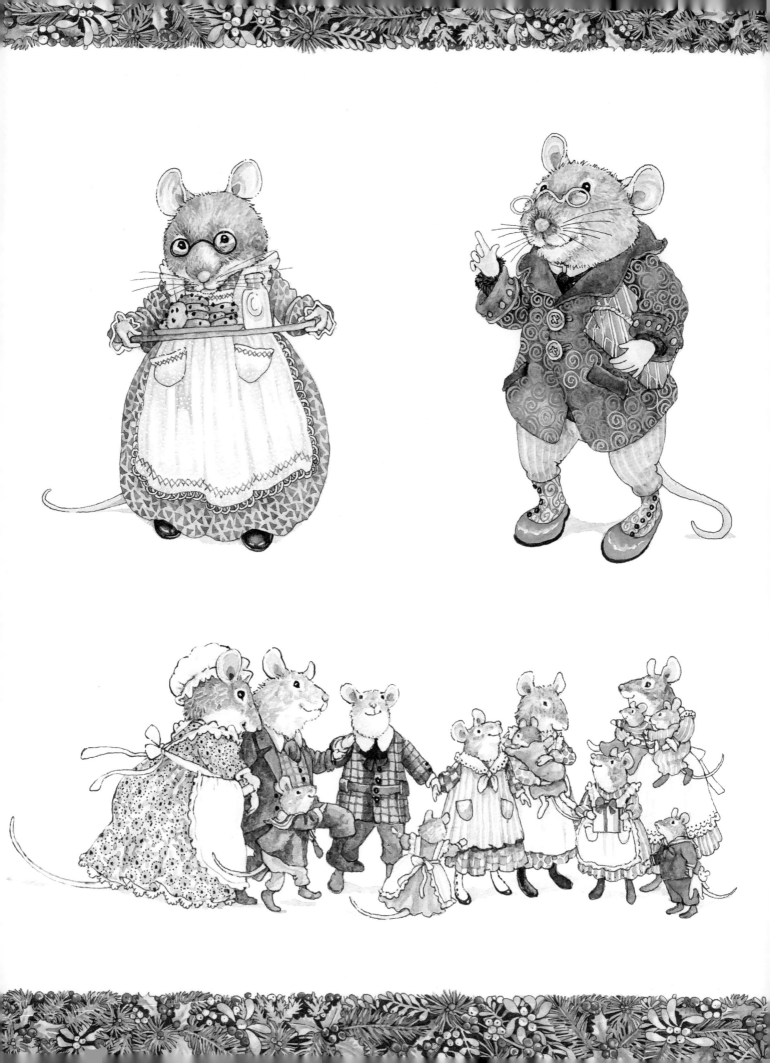

THE MICE BEFORE CHRISTMAS

Words by Anne L. Watson
Pictures by Wendy Edelson

Skyhook Press
Bellingham, Washington

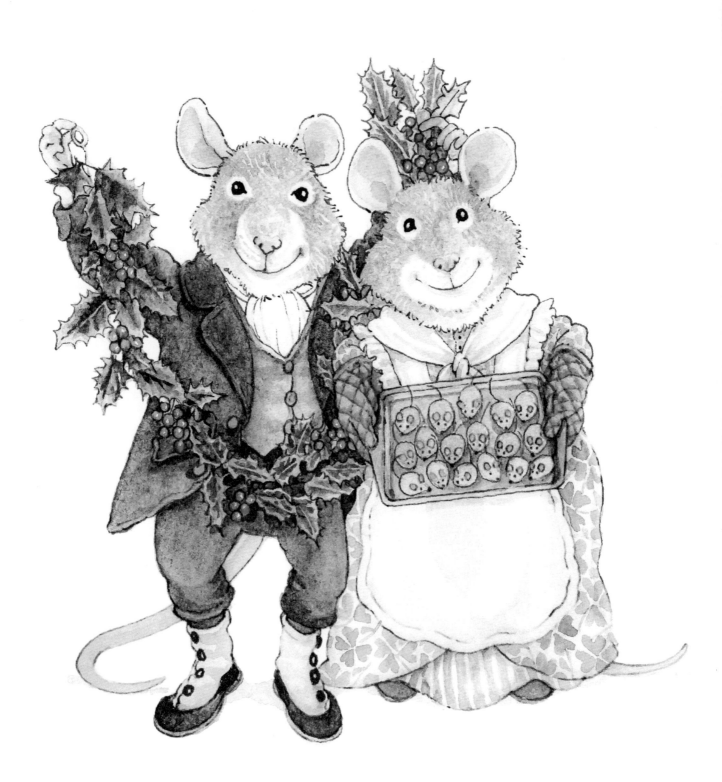

'Twas the day before Christmas, and all through their house,
The mice were preparing. There wasn't a mouse
Who didn't join in for the holiday flurry.
From top floor to bottom, they'd bustle and scurry.

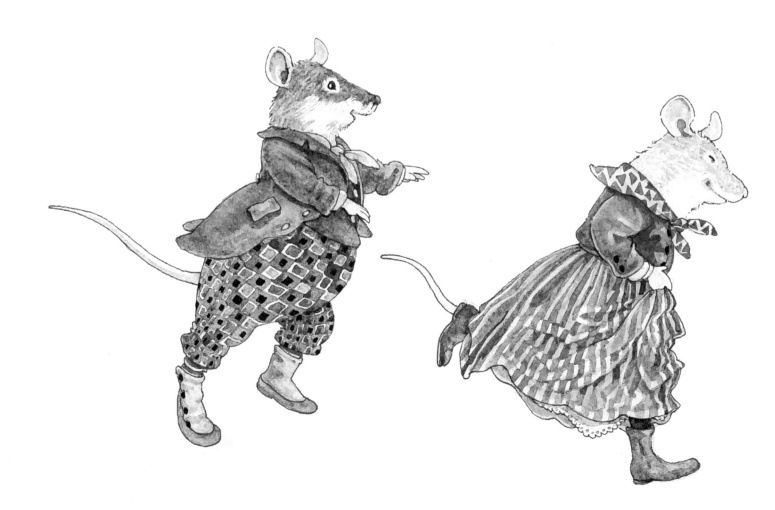

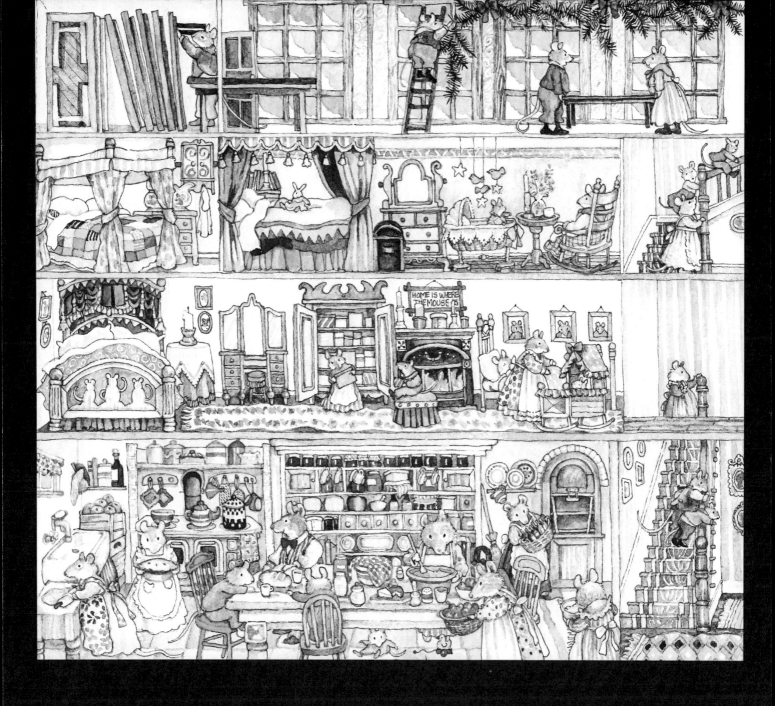

Their party was planned for that evening at eight,
With so much to finish before it got late!

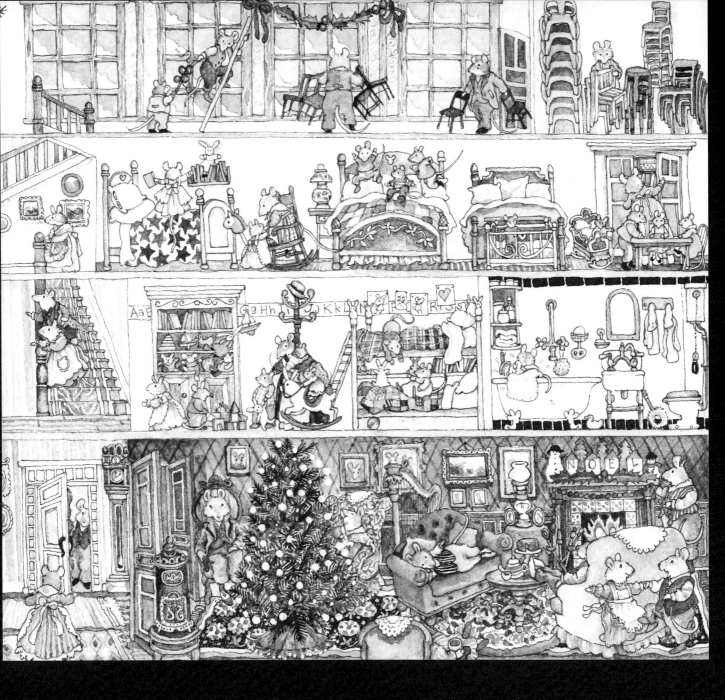

So, they scrambled and scampered—no task was neglected—
To deck out the halls for the guests they expected.

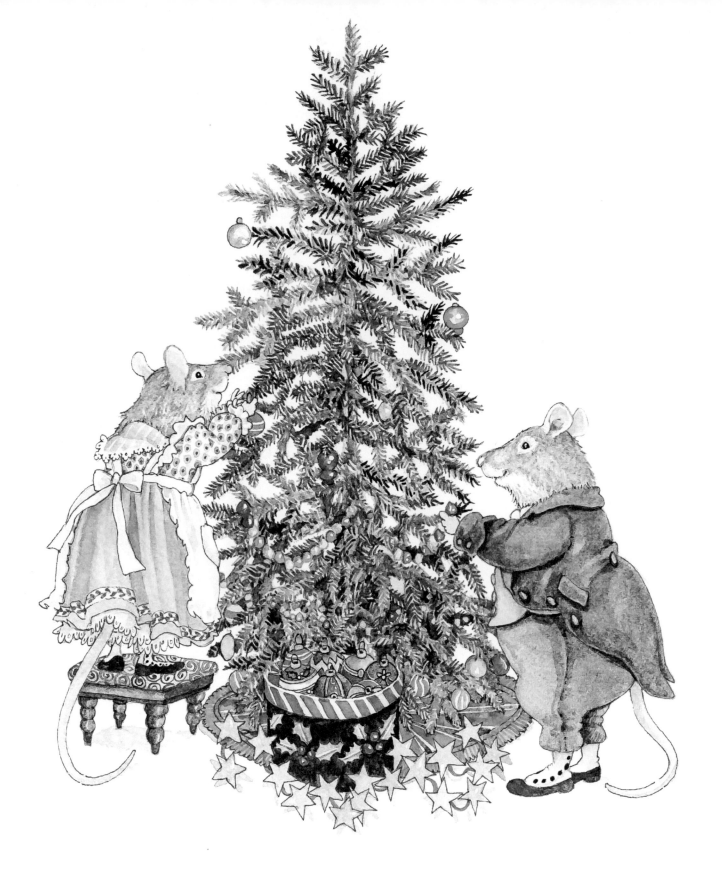

While Mama and Papa were trimming the tree,
The parlor was locked, and they'd taken the key.

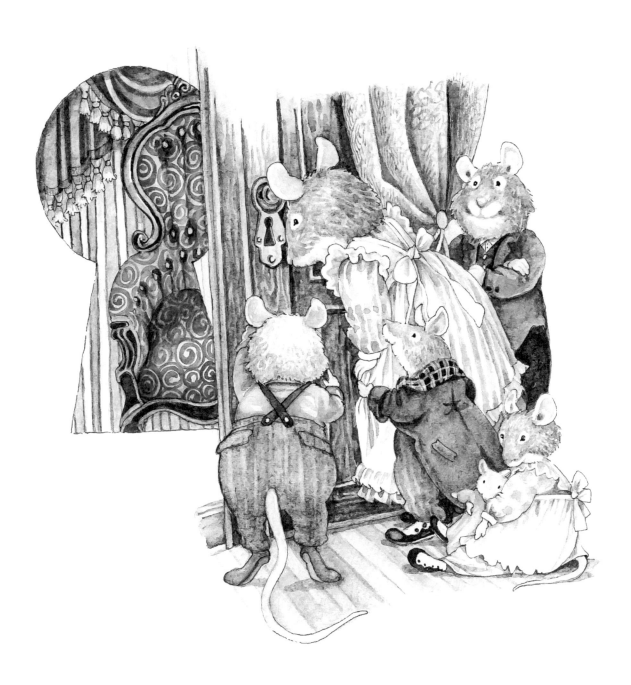

The children crept close to the keyhole to stare,
But saw only curtains, and maybe a chair.

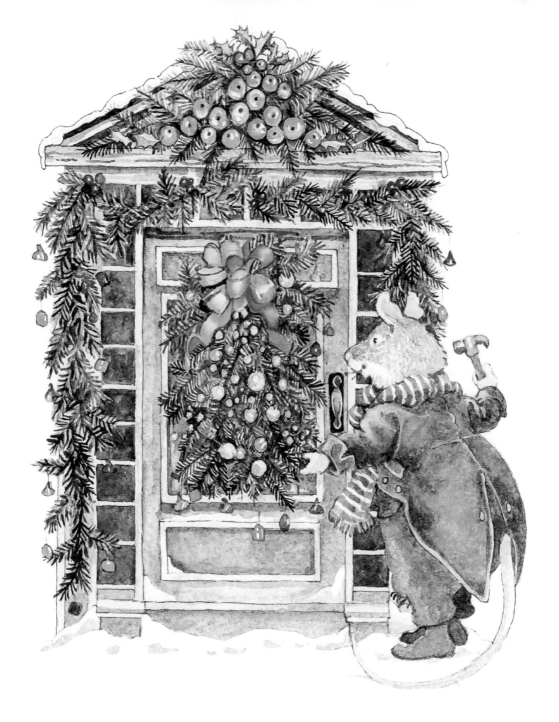

Then Uncle festooned the front door with bright trims,
With garlands of holly and evergreen limbs,
And garnished the branches, from doorstep to header,
With morsels of chocolate and pieces of cheddar.

The twins, in the front yard, were building twin snow mice,
While Aunt, in the kitchen, made gingerbread dough mice.
She opened the oven to check on the cooking,
And Billy snitched cookies while Aunt wasn't looking.

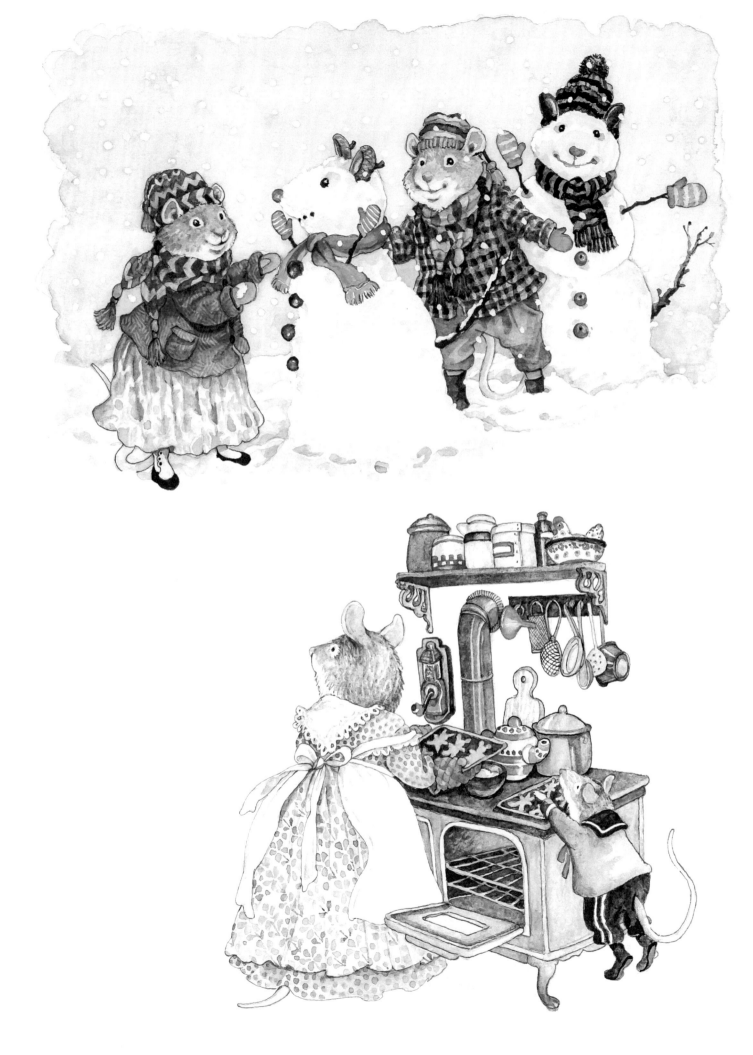

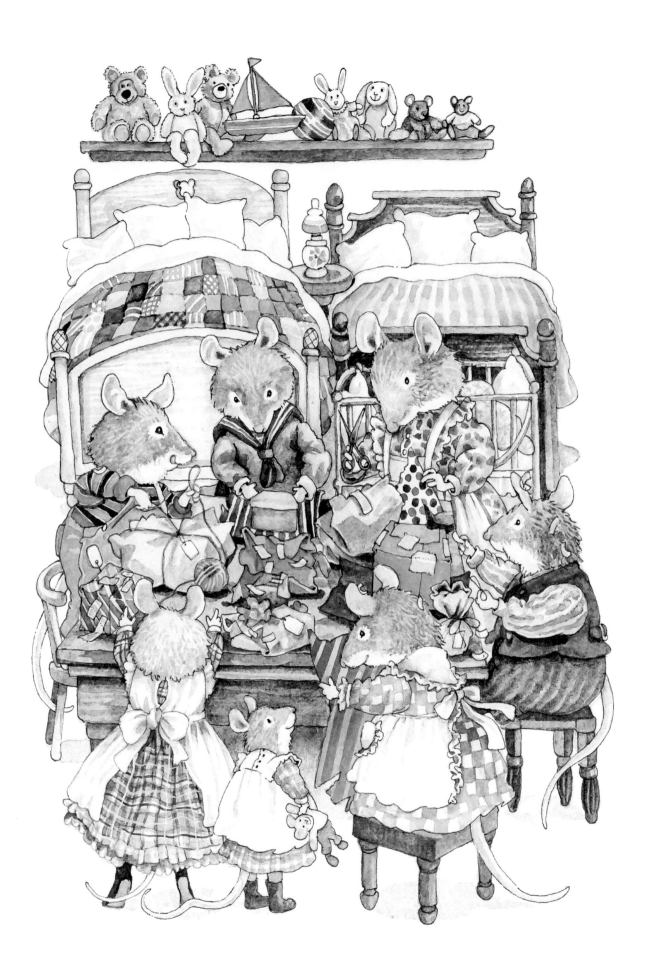

Upstairs in their bedroom, the littlest mice
Began wrapping gifts, doing everything twice.
They cut paper crooked, got tape in their fur,
And switched all the labels for him and for her.
Then with sisters and brothers, they thronged through the hall
To hang up their stockings. It took a whole wall!

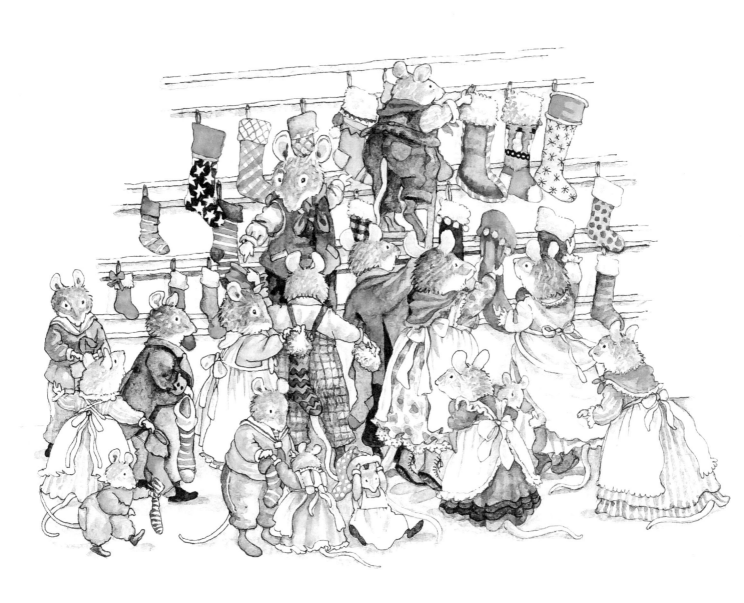

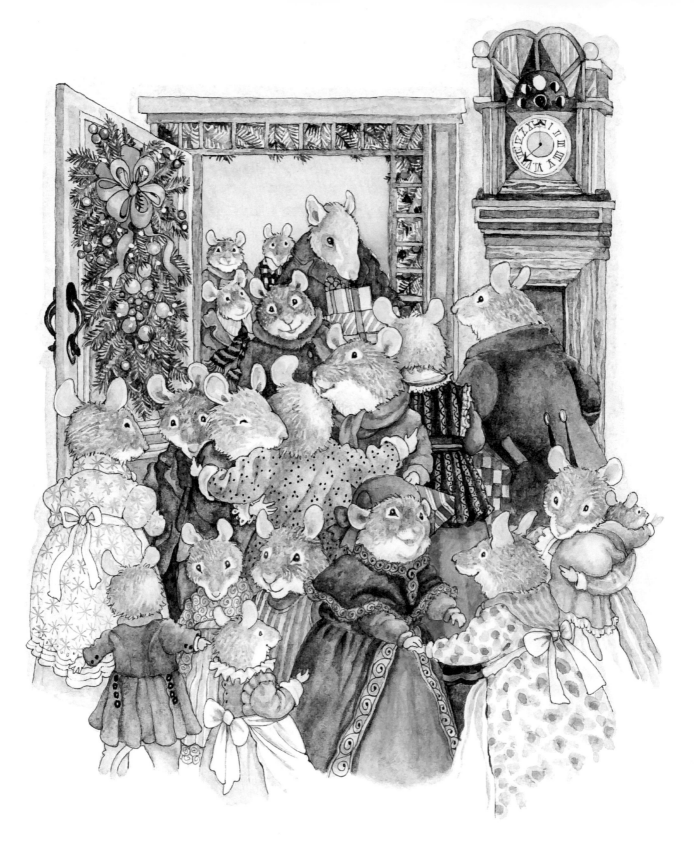

Excitement kept building—while patience did not—
Till the clock in the hallway reached eight on the dot.
As the chimes started sounding, the door was thrown wide,
And the guests in their finery crowded inside.

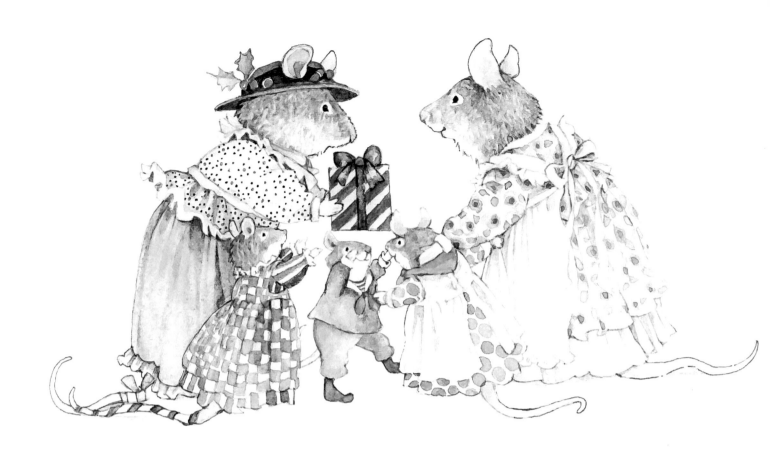

Good wishes and greetings turned into a din
Of merriments traded again and again.
"Merry Christmas to *you*!" "And to all in *your* nest!"
"I hope that the New Year will bring you the best!"
They chatted and drank steaming cider from mugs
That often got spilled in affectionate hugs.

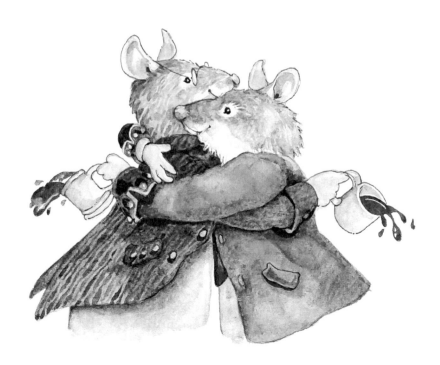

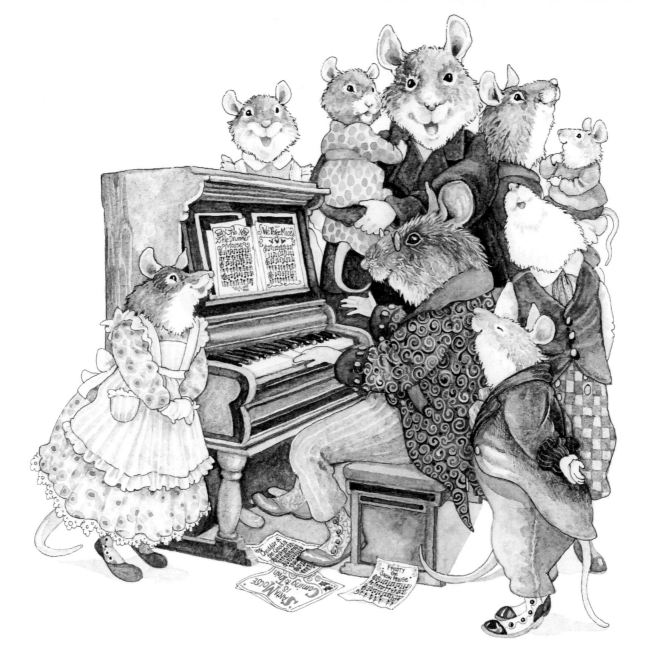

While Grandpa played tunes on an upright piano,
Matilda joined in with her squeaky soprano.
The mice gathered round, singing carols in parts.
Their voices rose high as they sang from their hearts.

At last it was time for the gifts! So they flocked
To the room with the tree, the big doors now unlocked.
The tree was so lovely, they gasped with delight.
It sparkled and shimmered, its candles so bright!
Its garlands of beads hung from silvery ties,
And the star shone on top like a star from the skies.

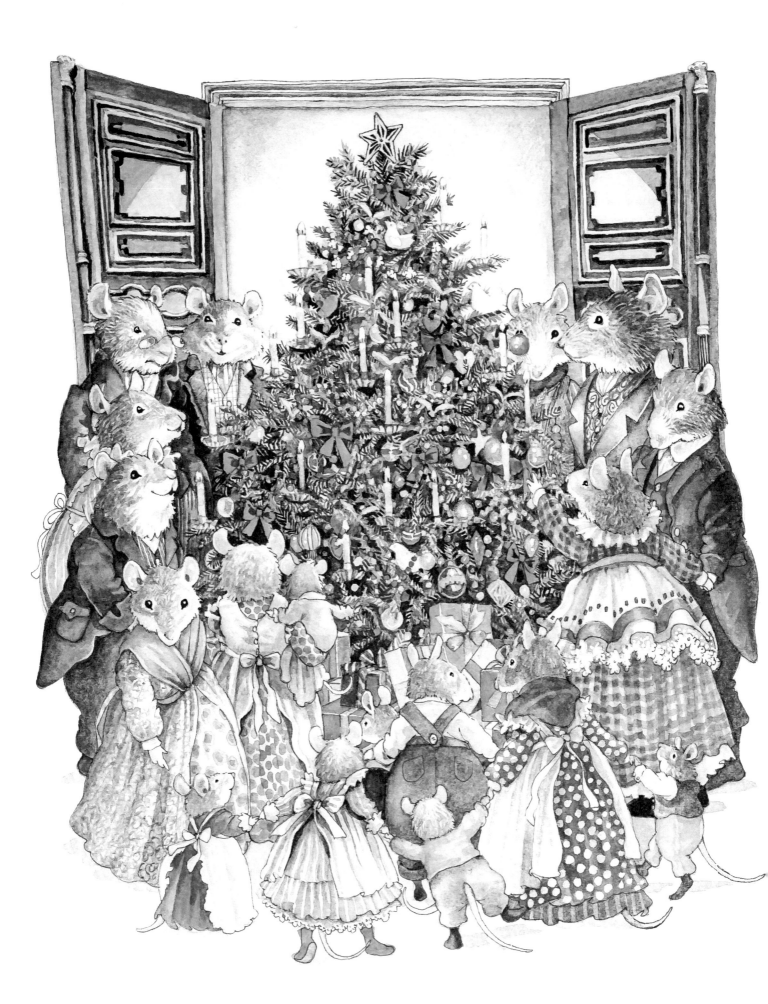

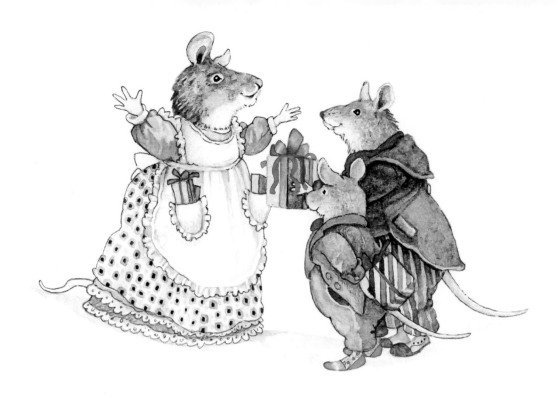

Beneath it were packages, gifts by the dozens,
For all the relations, for fourth and fifth cousins,
And presents for neighbors, and one for each friend,
For schoolfellows, tradespeople—gifts without end.

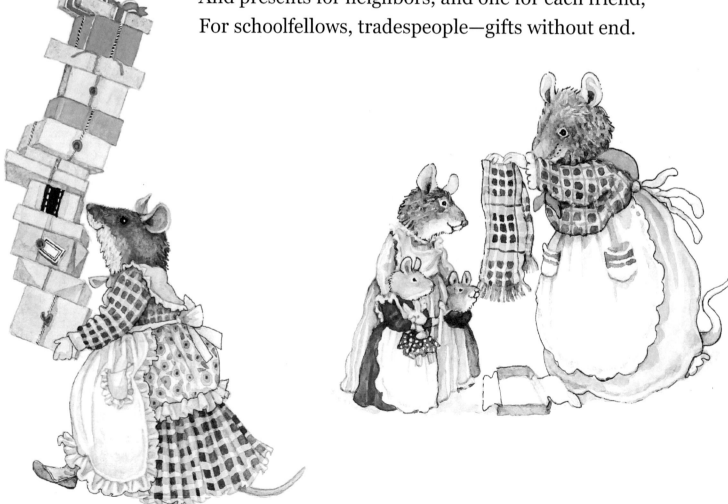

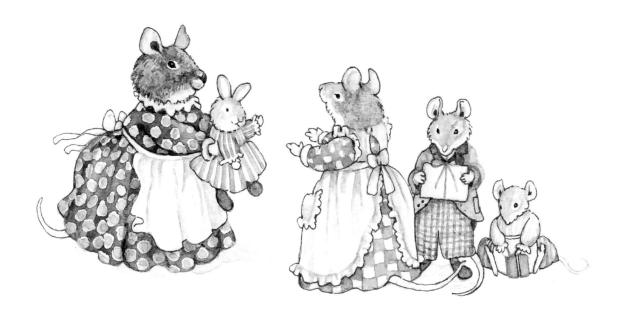

The mice unwrapped presents and savored the pleasure
Of each special thoughtfulness, each little treasure.
The gifts for the children were small, but they knew,
While they slept, Santa Mouse would be bringing some, too!

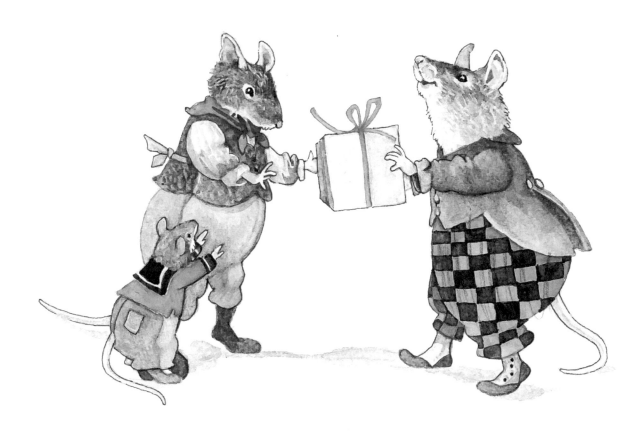

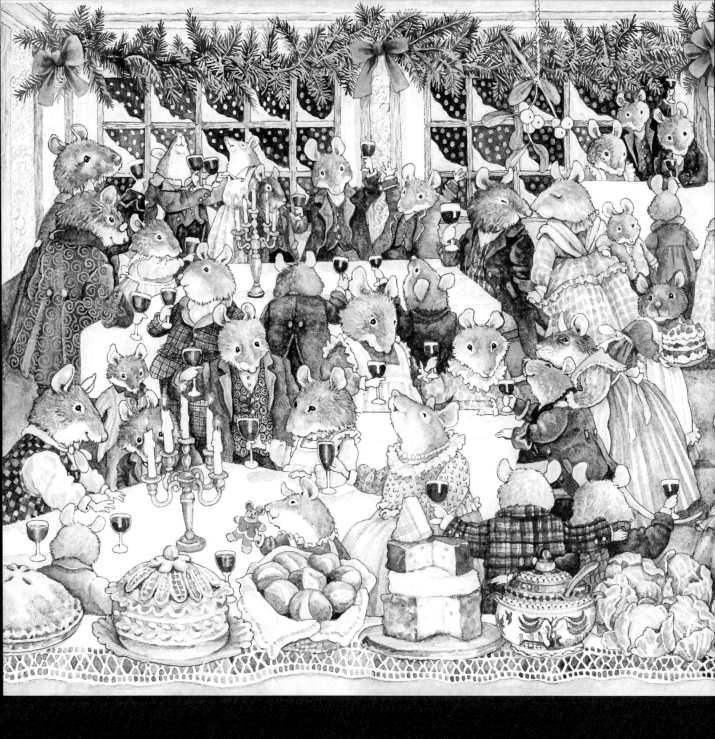

And after the singing and gifts came the feast.
Food enough for a week of such parties, at least!
There was course after course, and huge platters of cheese.
No dish was left out that could possibly please!

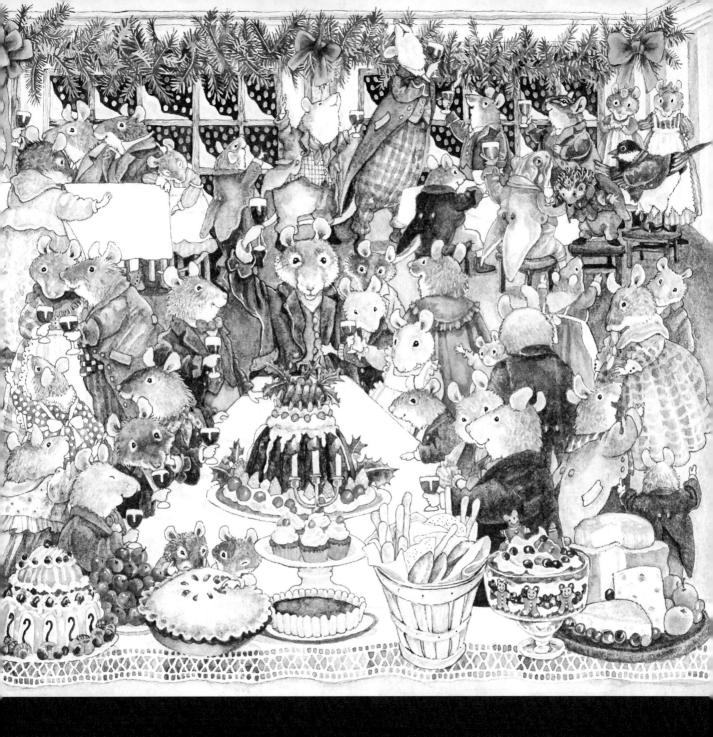

A flaming plum pudding came last, then the toasts
To the friends and relations, the guests and the hosts.
When all of the tributes and thanks had been said,
The sleepy small children were bundled to bed.

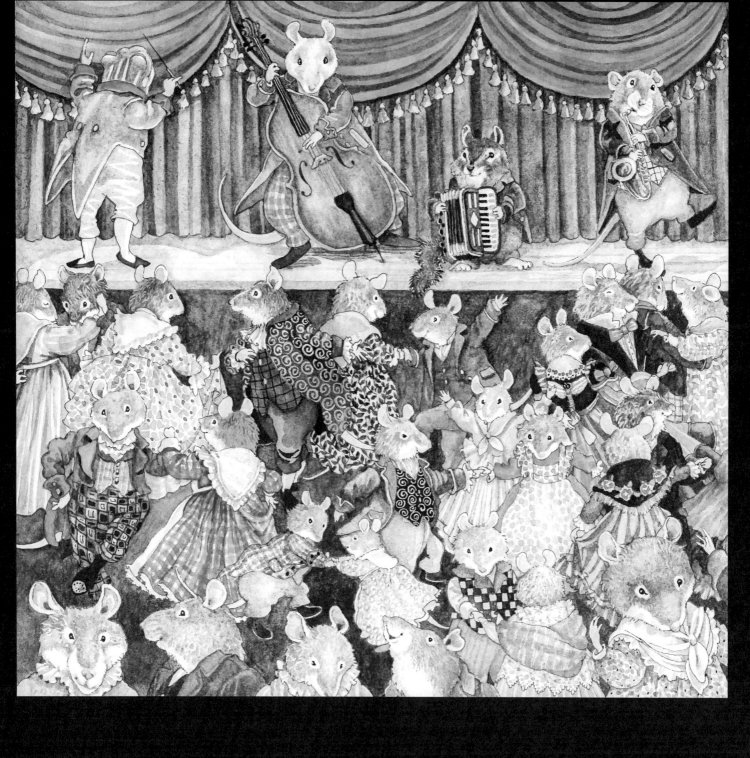

Then they pushed back the tables and cleared off the floor
As a seven-piece orchestra came through the door.

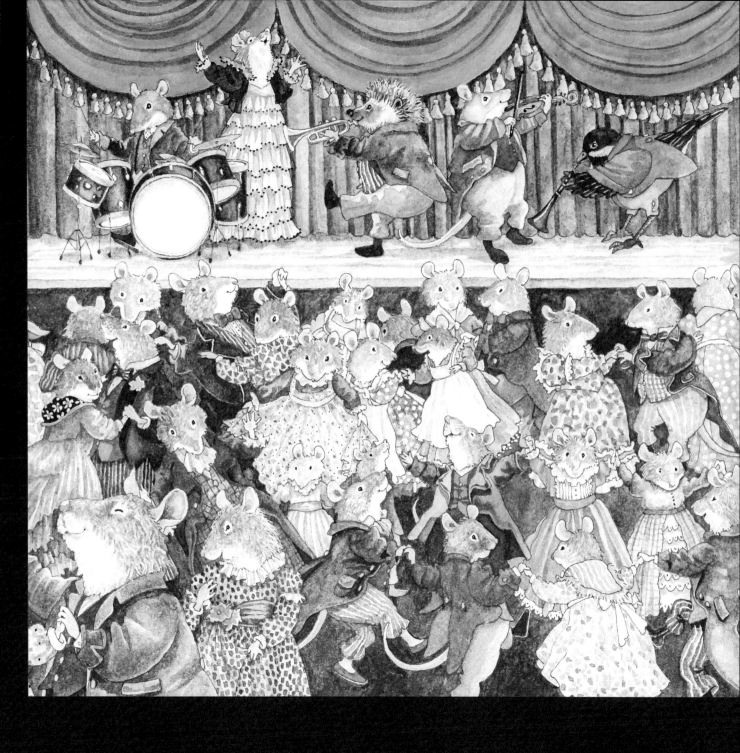

The conductor stood tall, his baton gave the cues,
And they danced like they all meant to wear out their shoes.

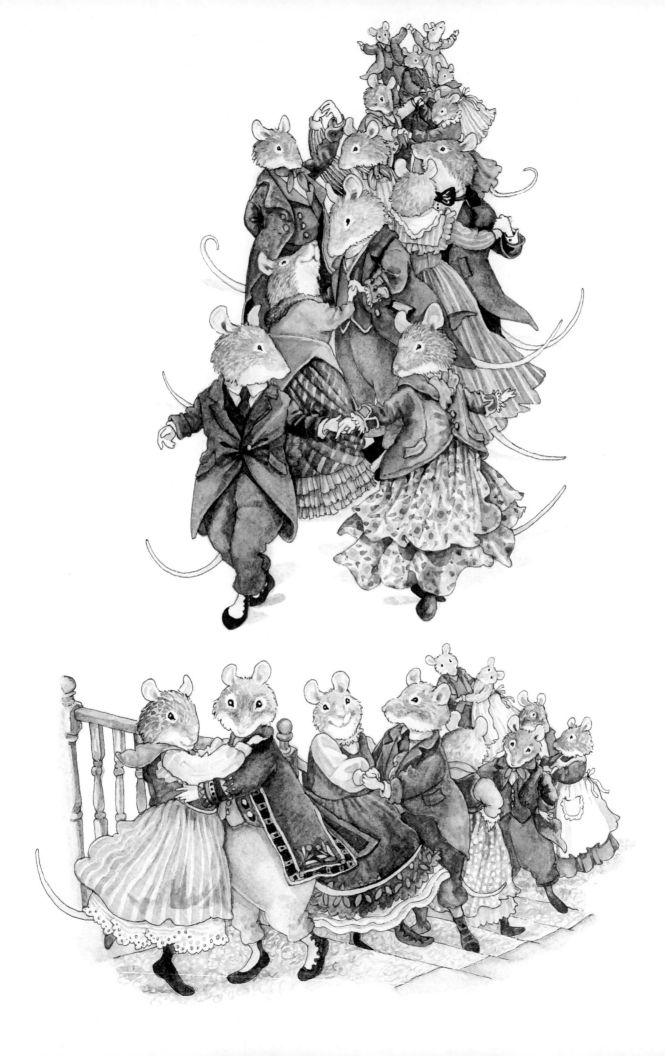

They were dancing in lines, they were dancing in pairs.
They waltzed down the hallways, they polkaed up stairs.
They spilled out the doorway in time with the tune
And danced with the snow mice beneath the full moon.

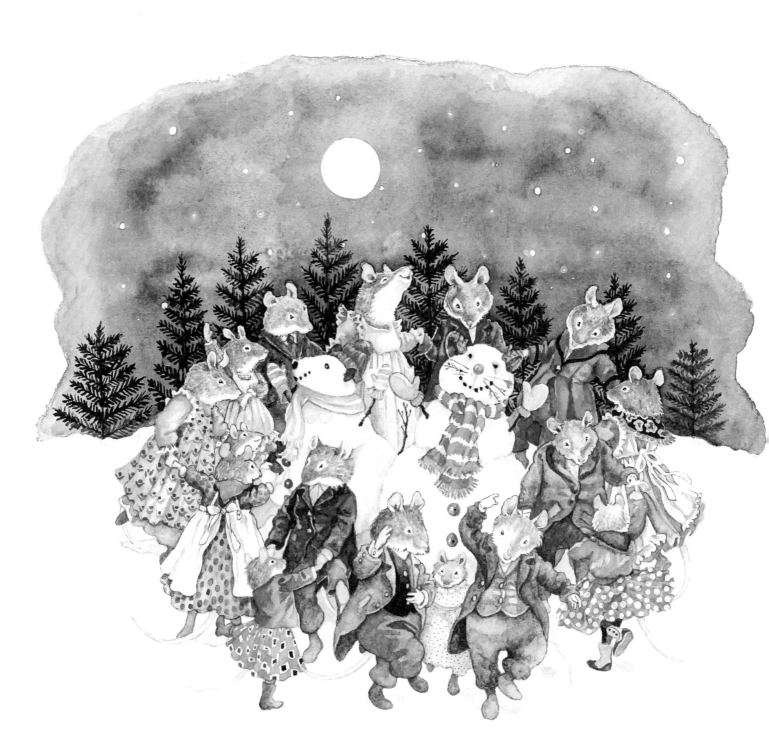

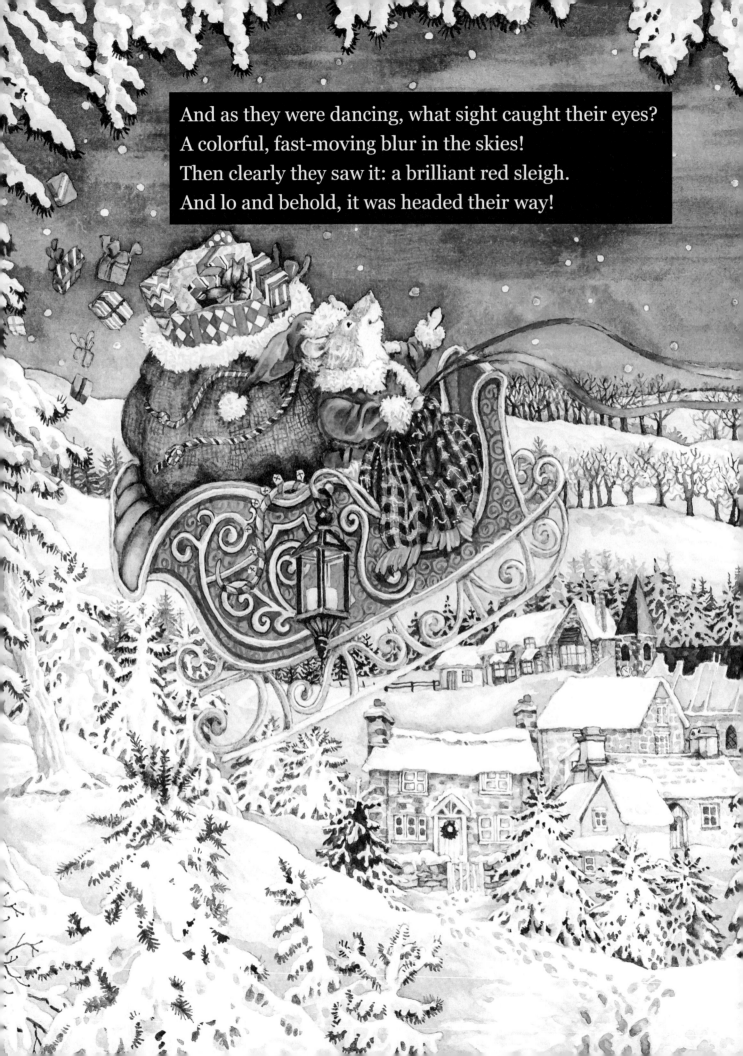

And as they were dancing, what sight caught their eyes?
A colorful, fast-moving blur in the skies!
Then clearly they saw it: a brilliant red sleigh.
And lo and behold, it was headed their way!

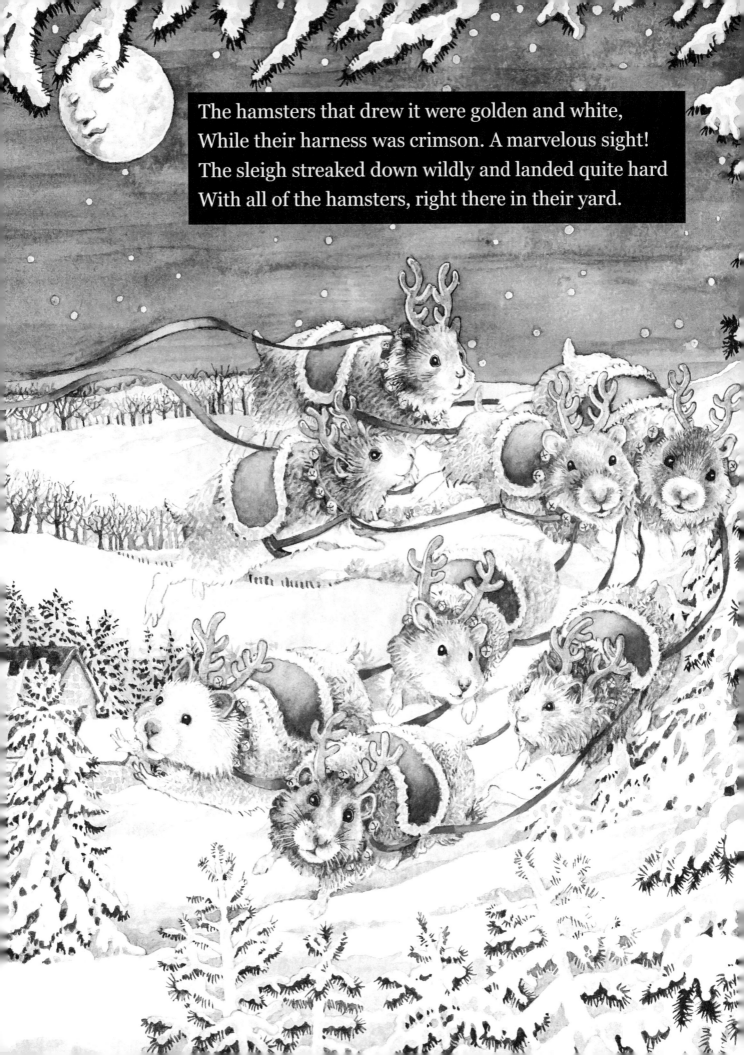

The hamsters that drew it were golden and white,
While their harness was crimson. A marvelous sight!
The sleigh streaked down wildly and landed quite hard
With all of the hamsters, right there in their yard.

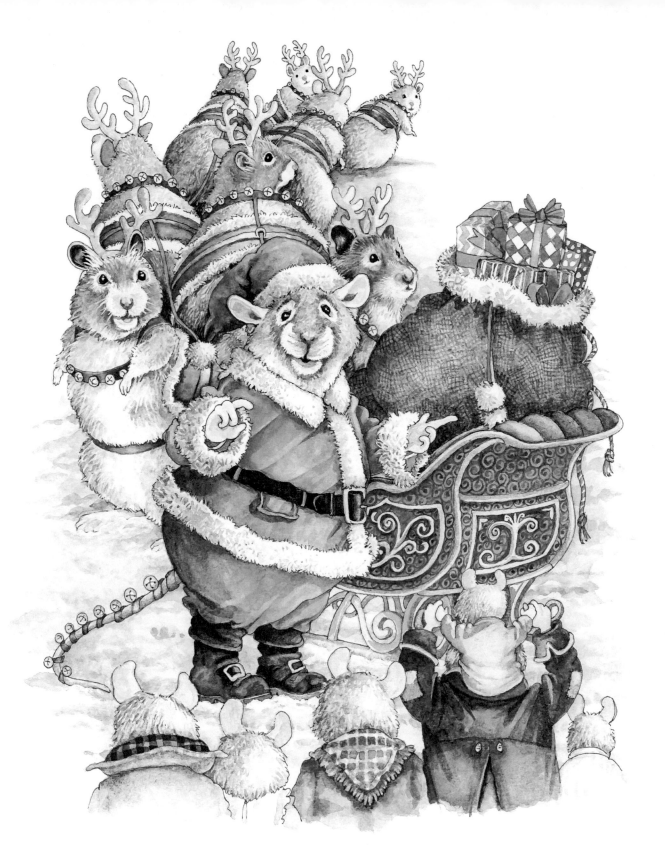

Then their eyes all grew wide as the driver stepped down
With a look quite perplexed and a puzzling frown.
"It's Santa Mouse!" "Santa Mouse!" all of them cried.
And they ran to the sleigh to escort him inside.

But Santa Mouse stood by his hamsters and said,
"I'm sorry to say that there's trouble ahead.
A problem I've never run into before!
I won't fit your chimney, or even your door!
You've so many children, and all were so good,
I'm afraid this big bag won't squeeze through as it should."

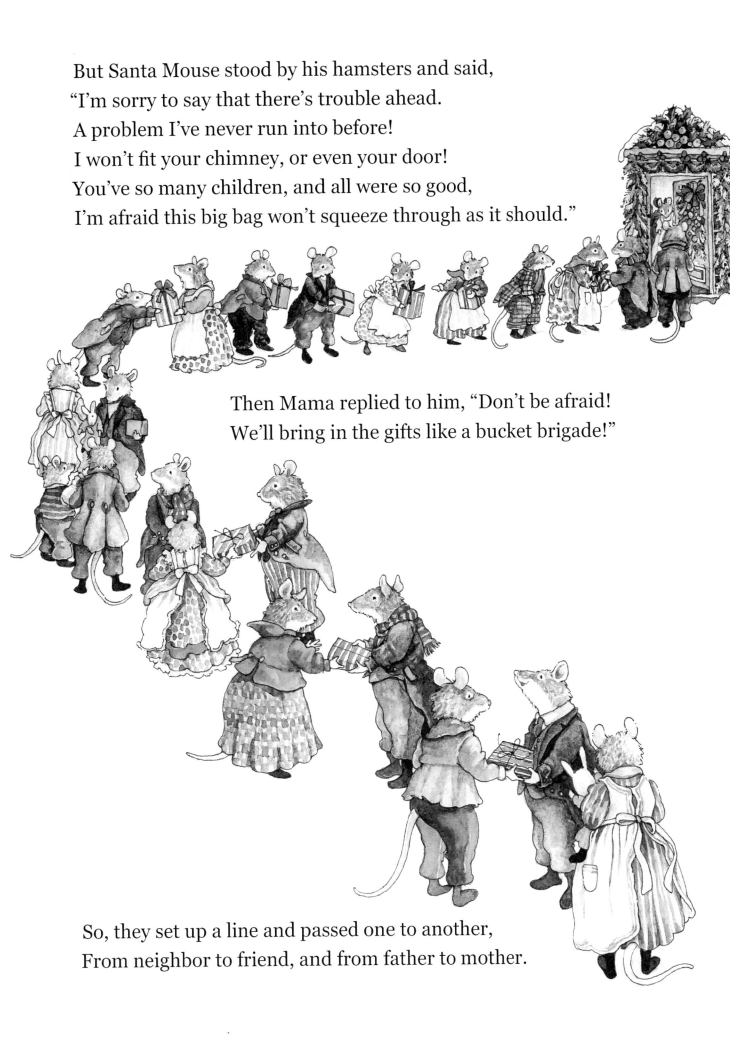

Then Mama replied to him, "Don't be afraid!
We'll bring in the gifts like a bucket brigade!"

So, they set up a line and passed one to another,
From neighbor to friend, and from father to mother.

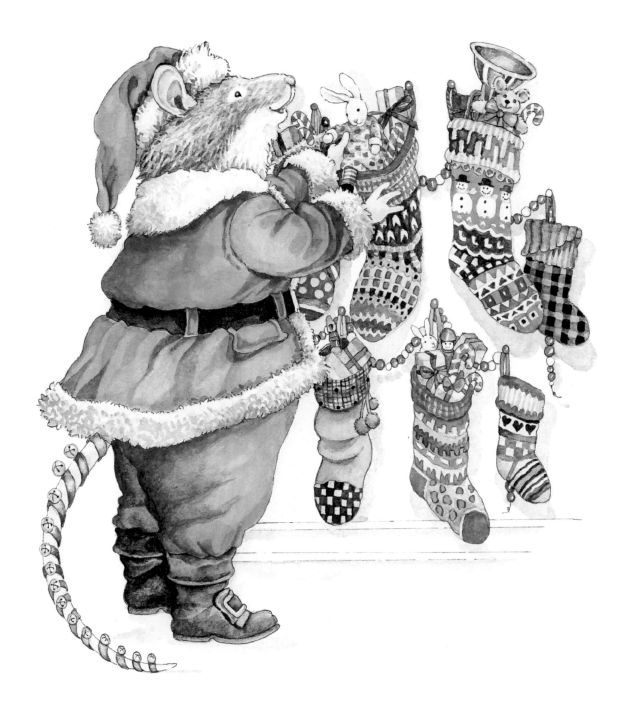

When all was inside, Santa came in the house,
And he filled up a stocking for each little mouse.
Then all the big toys, he set under the tree
While he joked and he laughed. It was jolly to see!

Then Grandma, with cookies and milk for his thirst,
Said, "Don't you dare go till you've eaten this first!"
He gratefully munched and declared through a bite,
"Merry Christmas to all, and to all a good night!"

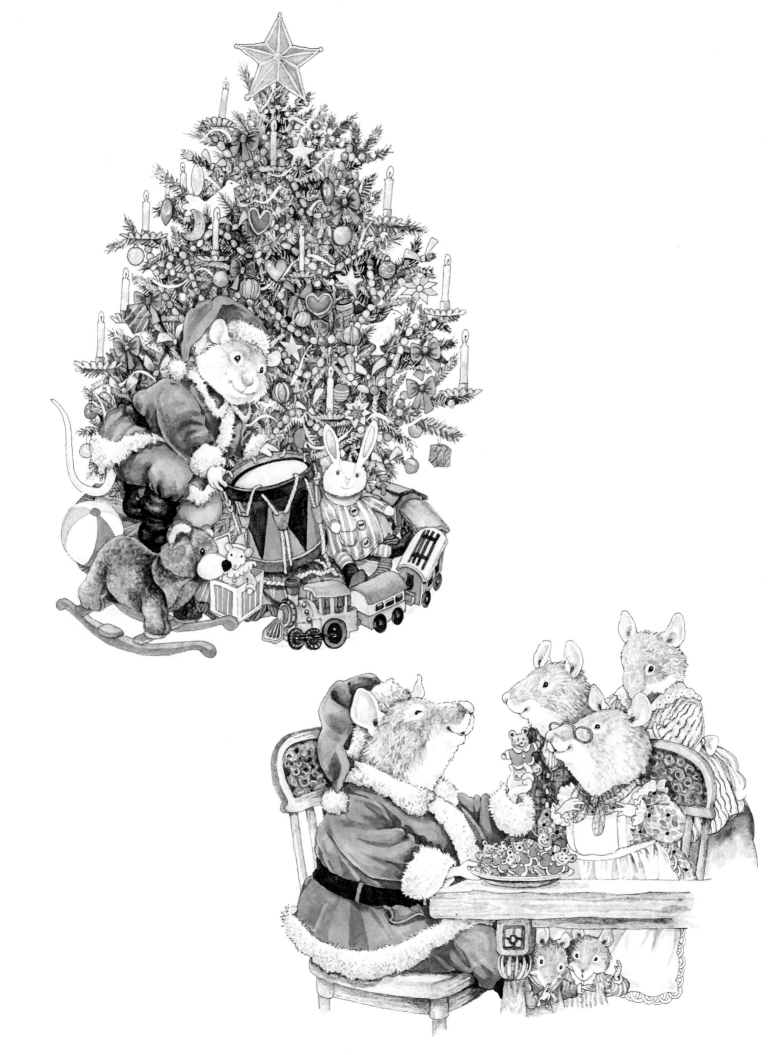

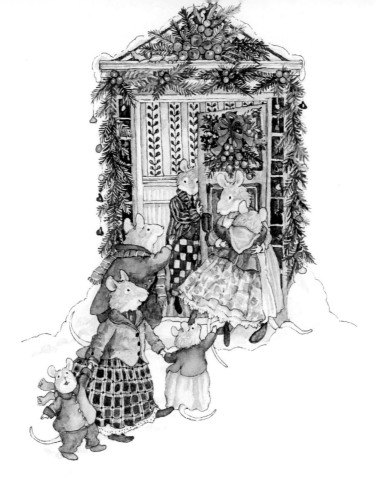

When Santa Mouse left, all the guests went home, too.
They were nearly worn out, there'd been so much to do!
Then the rest of the family fell into beds,
Too tired for sugarplums dancing through heads.

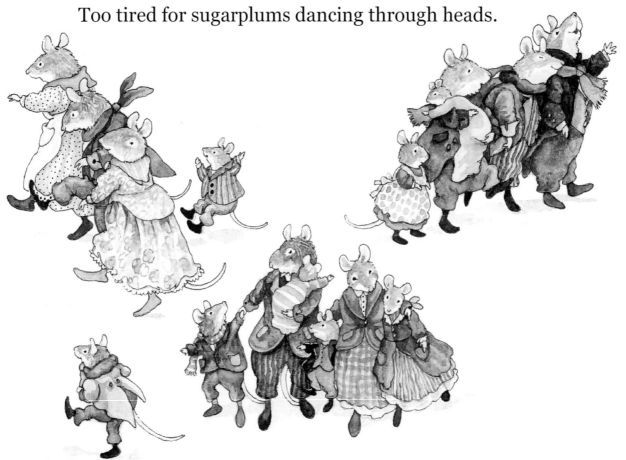

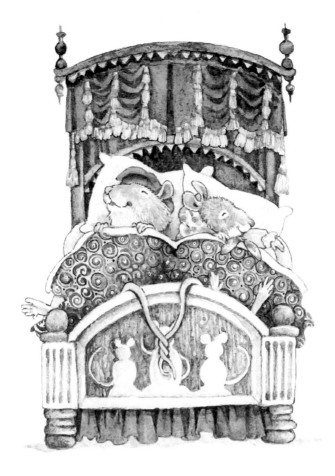

'Twas the night before Christmas, and all through the house,
Not a creature was stirring—

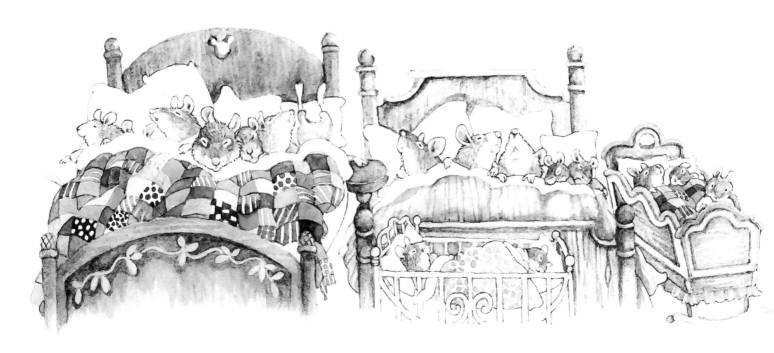

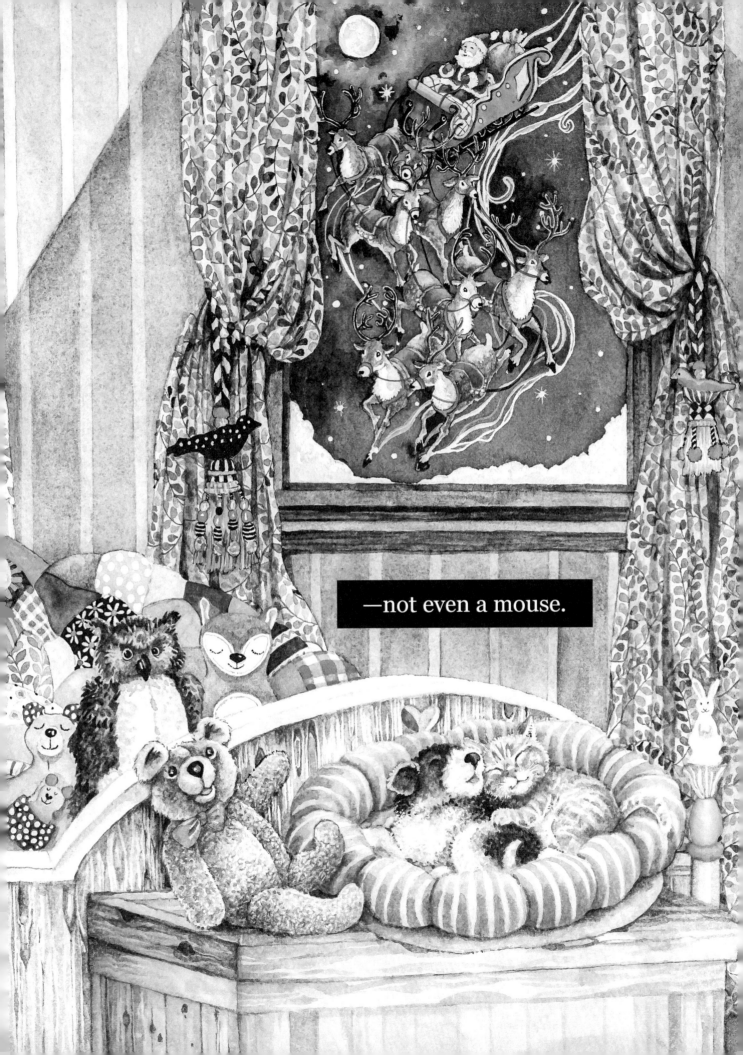

—not even a mouse.

ABOUT THE CHILDREN'S BOOK

This coloring book is adapted from the children's picture book *The Mice Before Christmas*, by Anne L. Watson, illustrated by Wendy Edelson, published in 2021 by Skyhook Press. It was conceived as an imaginative prequel to Clement Clarke Moore's famous poem "The Night Before Christmas."

ABOUT THE ILLUSTRATOR

Wendy Edelson has applied her award-winning skills to a wide range of illustration projects, including picture books, pet portraits, posters, and puzzles. Among her clients have been Simon & Schuster, Seattle's Woodland Park Zoo, the Seattle Aquarium, Pacific Northwest Ballet, the U.S. Postal Service, *Cricket Magazine*, McGraw-Hill Education, and the American Library Association. Her more recent projects have included several picture books and coloring books for Skyhook Press. The pictures in this coloring book were converted to grayscale from Wendy's original watercolor illustrations. Visit her at **www.wendyedelson.com**.

ABOUT THE AUTHOR

Anne L. Watson is the author/illustrator of *Katie Mouse and the Perfect Wedding*, *Katie Mouse and the Christmas Door*, *The Secret of Gingerbread Village*, and other children's books, as well as the author of numerous craft books and novels for adults. She lives in Bellingham, Washington, with her husband and fellow author, Aaron Shepard. Visit her at **www.annelwatson.com**.

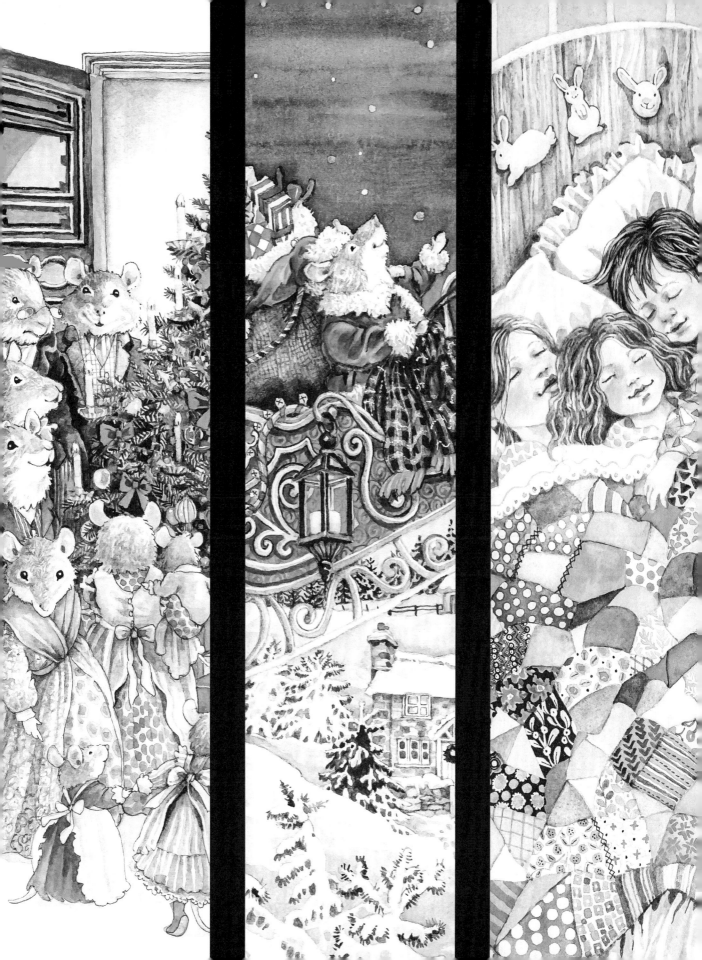

More Grayscale Coloring...

THE
Baker's Dozen
COLORING BOOK

PICTURES BY WENDY EDELSON • STORY BY AARON SHEPARD

AMAZING GRAYS #1

A GRAYSCALE ADULT COLORING BOOK
WITH 50 FINE PHOTOS OF PEOPLE,
PLACES, PETS, PLANTS & MORE

More Grayscale Coloring . . .

Lightning Source UK Ltd.
Milton Keynes UK
UKRC030359190722
406043UK00004B/261